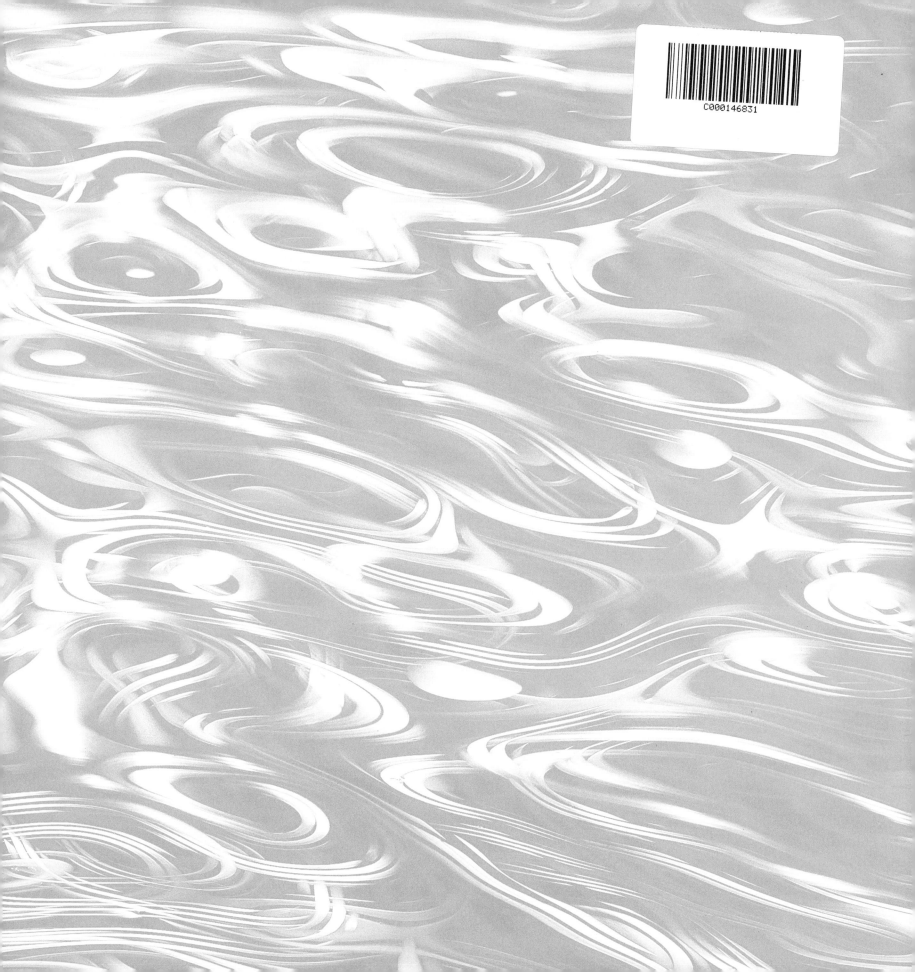

FLEETING REFLECTIONS
FLEETING REFLECTIONS

MIKE CURRY

 TriplekiteBooks

www.TriplekiteBooks.com

First published in 2017 by Triplekite Publishing.

www.mikecurryphotography.com

A catalogue record for this book is available from the British Library.
ISBN 978-0-9932589-7-8

Printed in Malta.

INTRODUCTION

The sense of energy at Canary Wharf is palpable; it's not a place that is often associated with quiet contemplation. Yet pausing for a moment reveals real beauty and softness alongside the corporate architecture; the patterns and colours can be mesmerizing like a kaleidoscope as they change with the light and weather.

With so much activity all around, capturing these colourful images requires a focus that isn't immediately obvious to passers by; I can spend hours at a time examining one body of water, waiting for something out of the ordinary. I sometimes think I might be the only person who is still among the crowd. The more I stand and watch the more I see, yet the more I look the more I notice that 'looking' is futile, it's more about feeling and anticipating.

The images in this book are inspired by my childhood fascinations with kaleidoscopes and Spirograph and being captivated by the endless variation of colours and shapes you could create. The photographs may seem like they have been manipulated or created in Photoshop but they appear in this book as they did for me while capturing them, as beautiful fleeting reflections.

Mike Curry

MORNING
MORNING

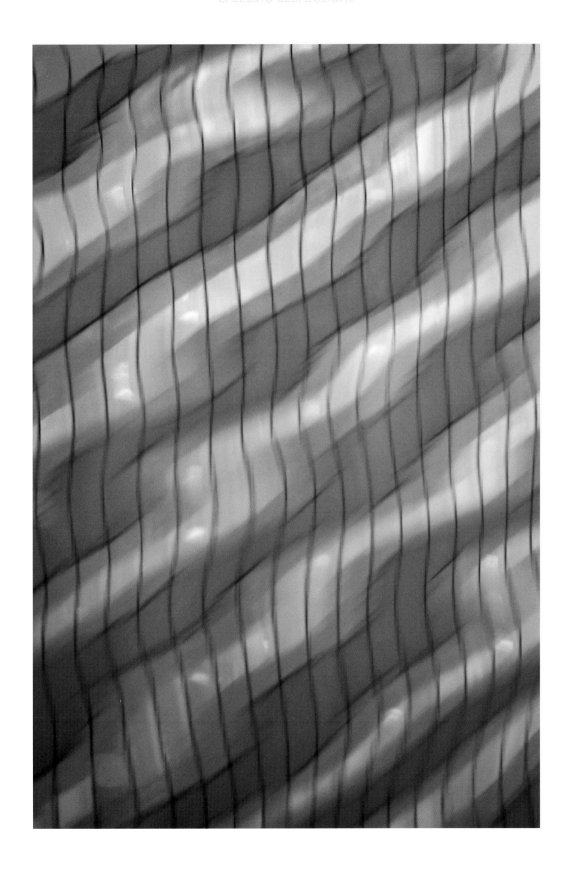

FLEETING REFLECTIONS

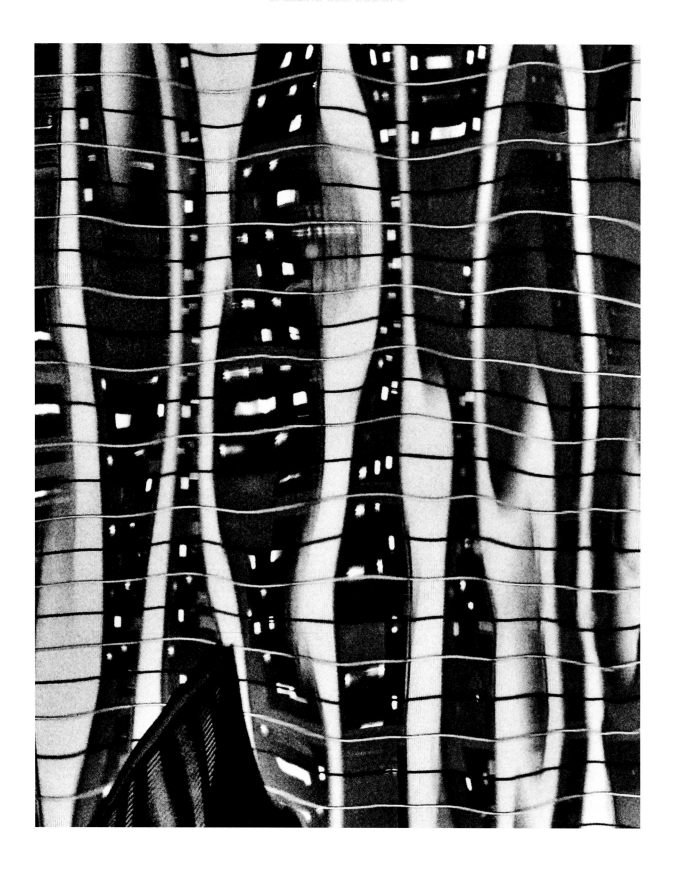

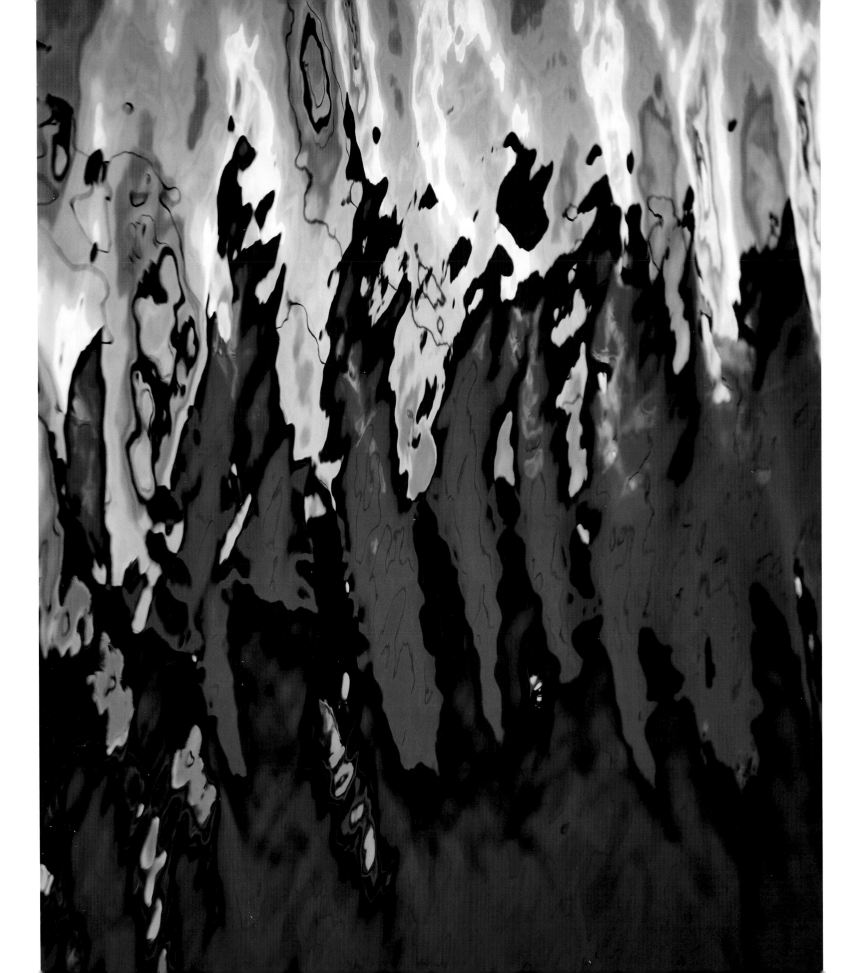

FLEETING REFLECTIONS

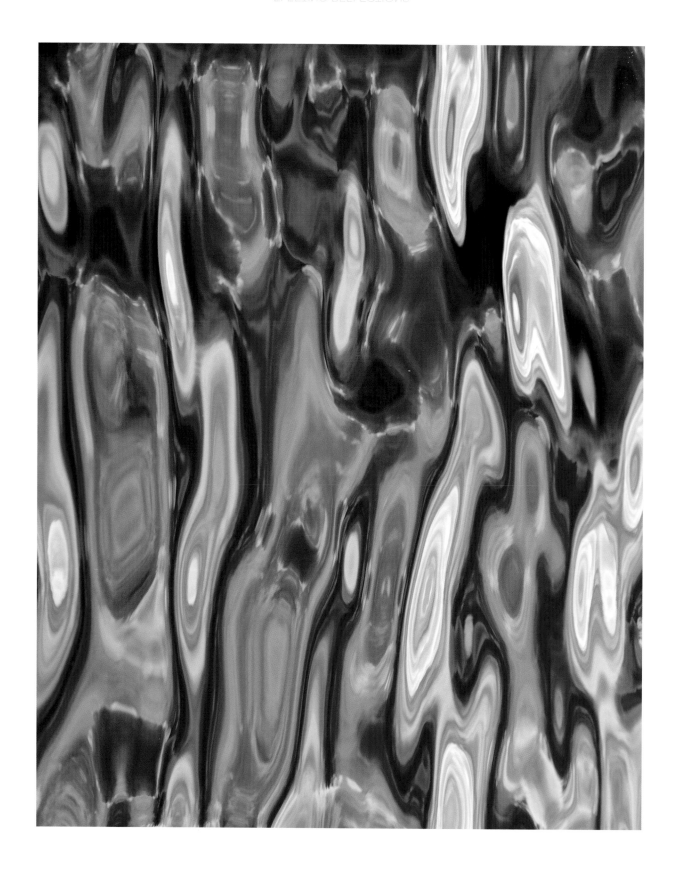

FLEETING REFLECTIONS

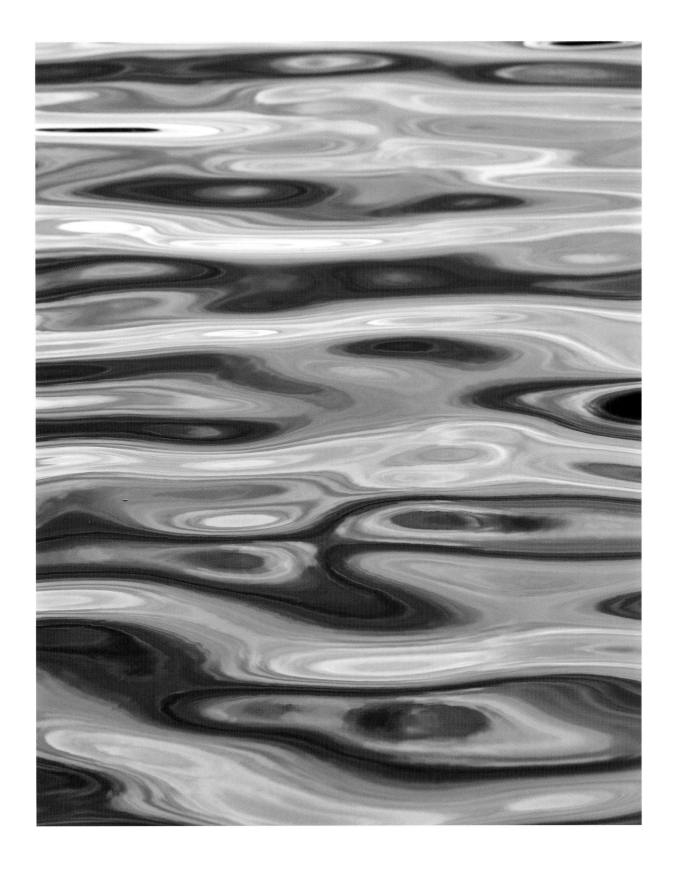

FLEETING REFLECTIONS

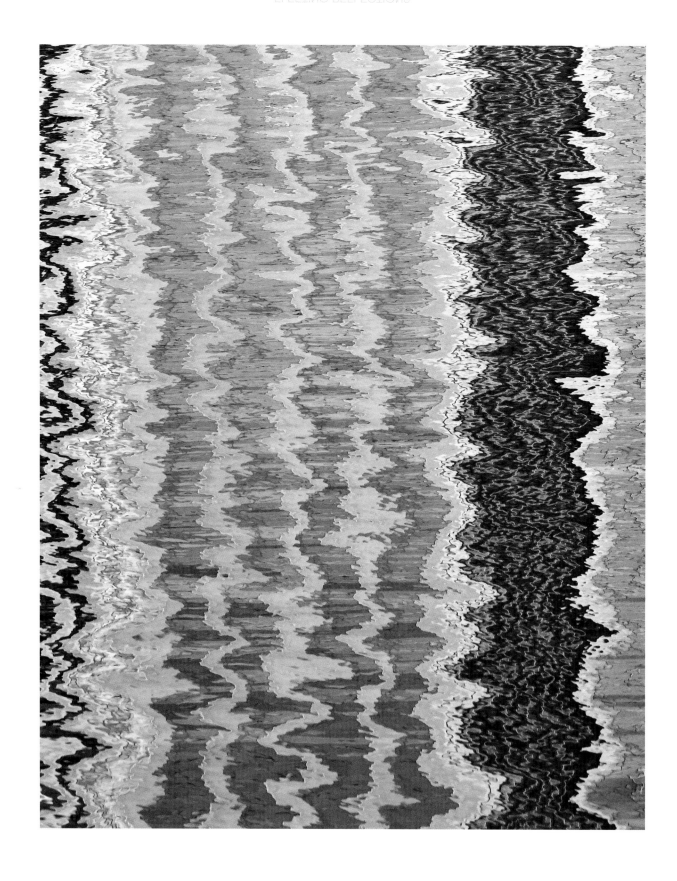

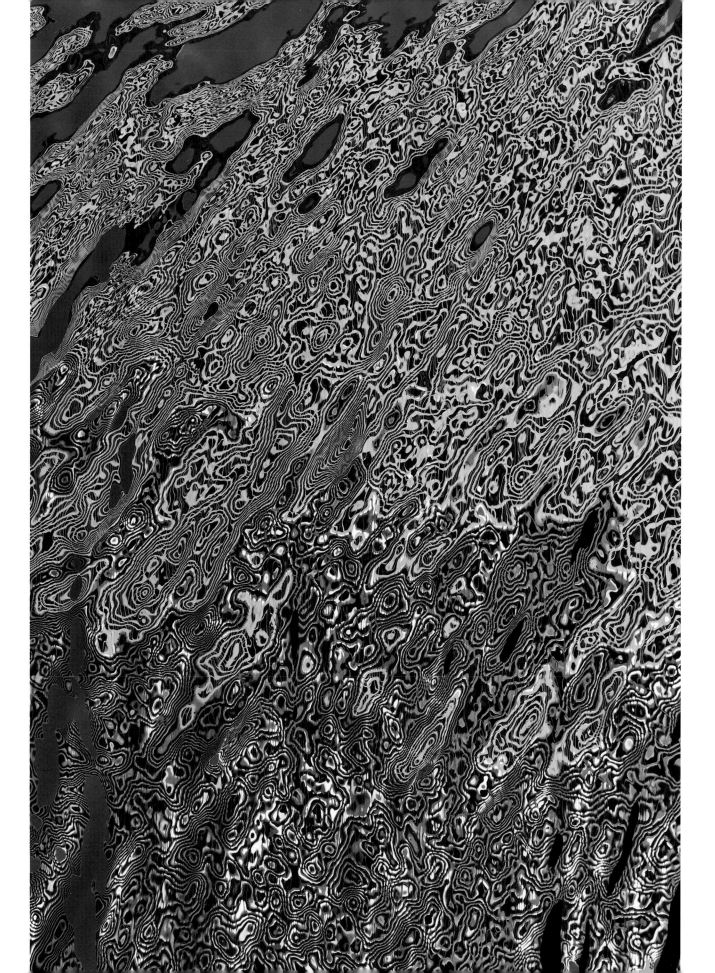

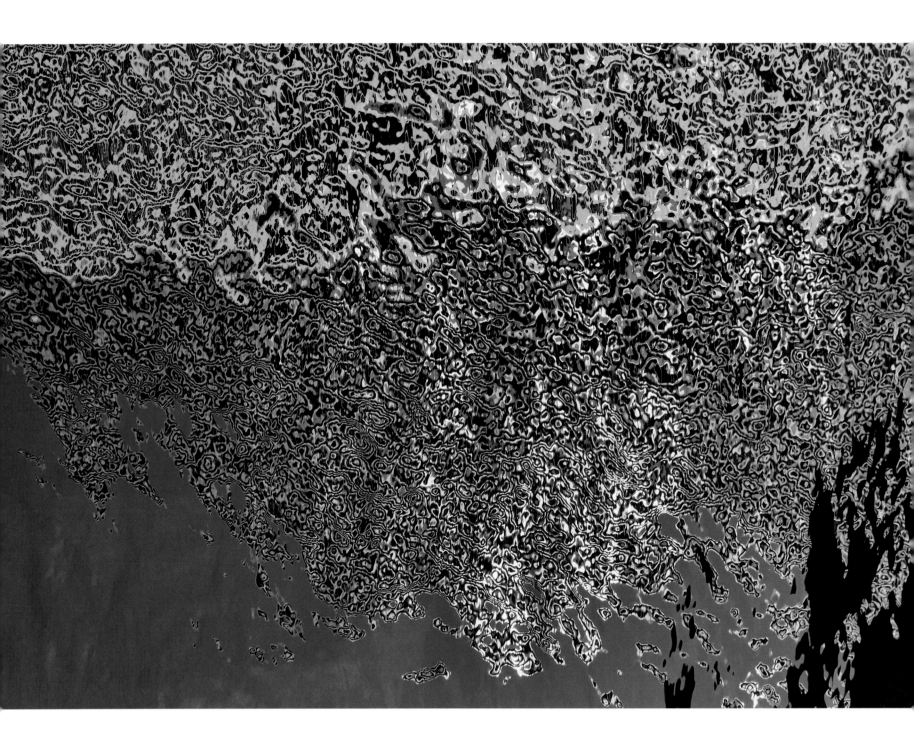

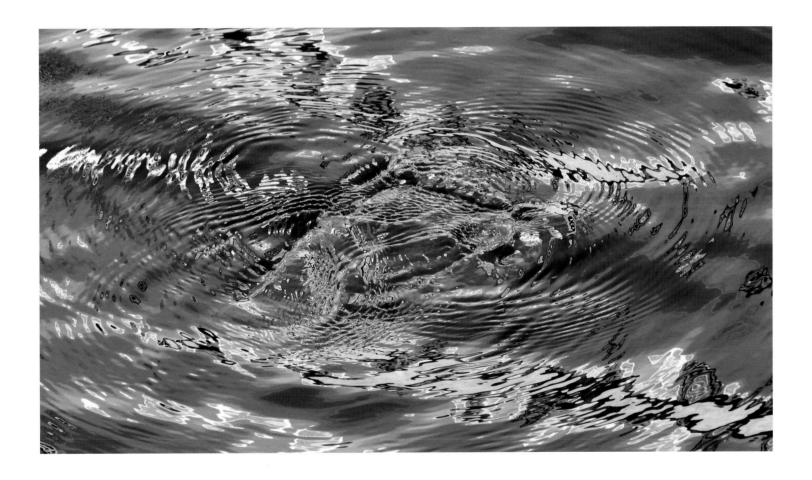

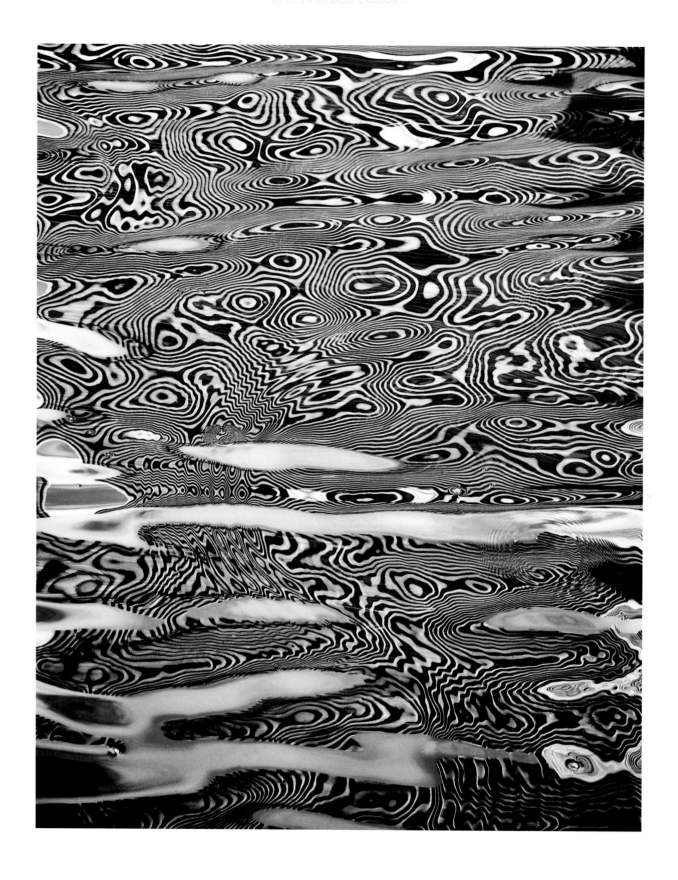

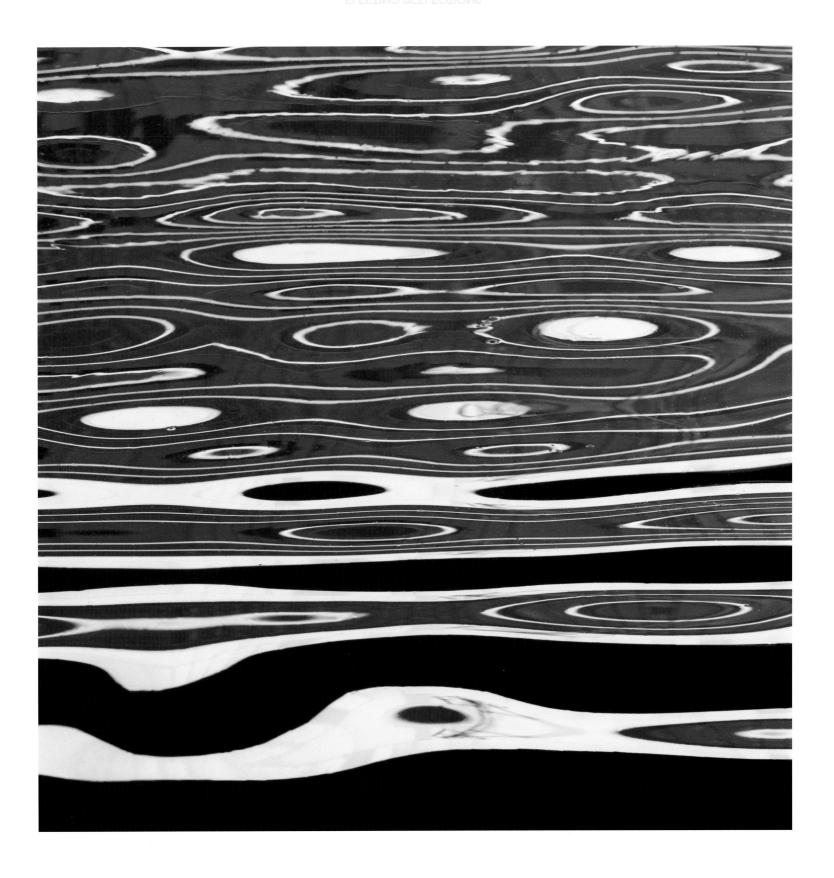

FLEETING REFLECTIONS

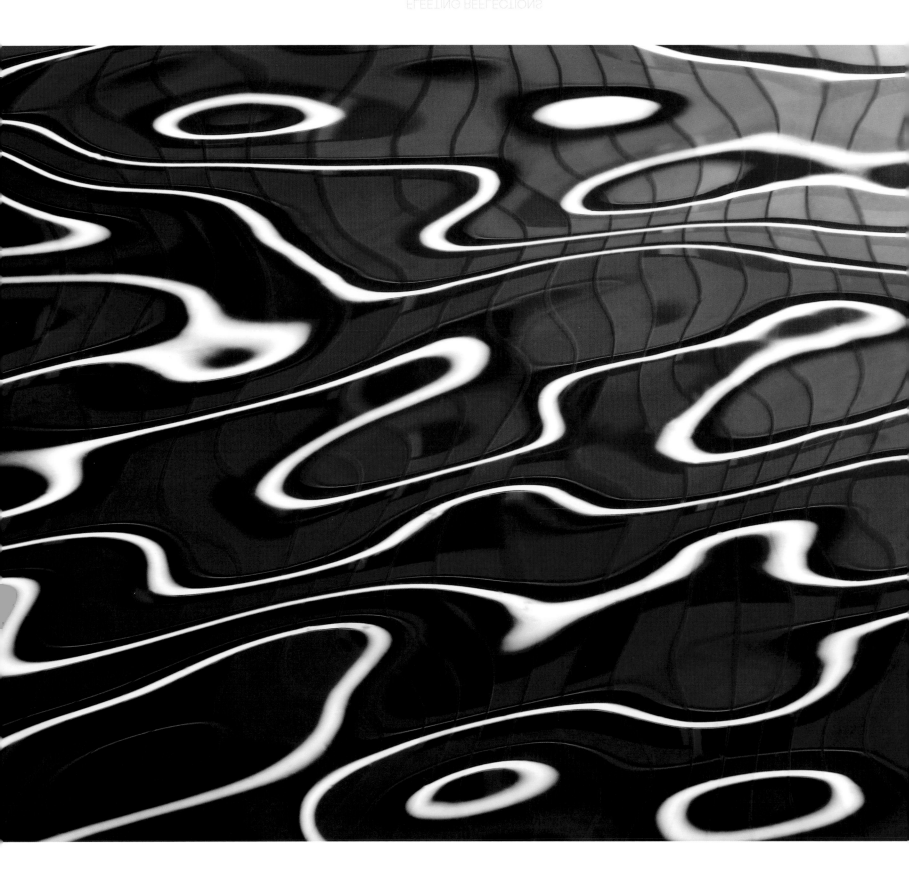

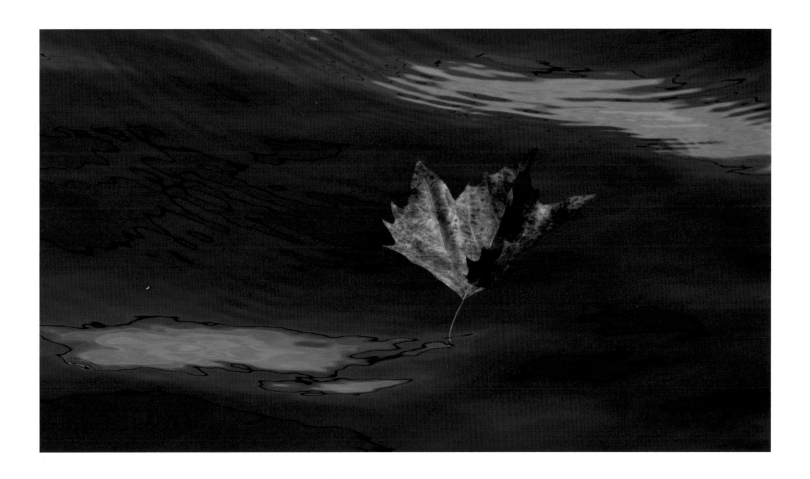

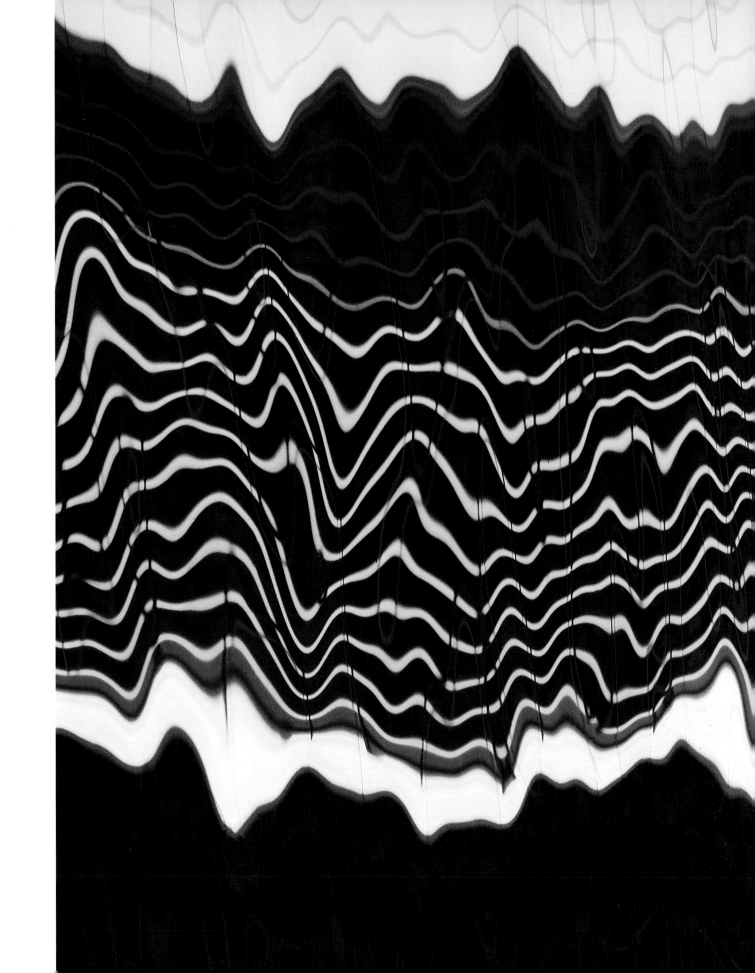

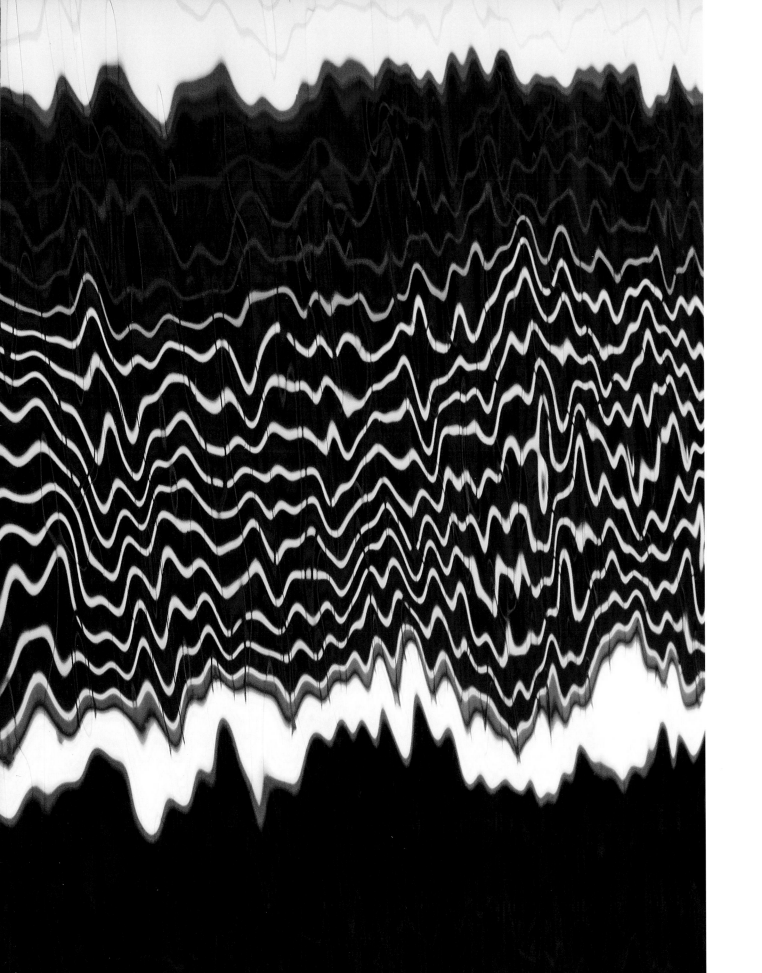

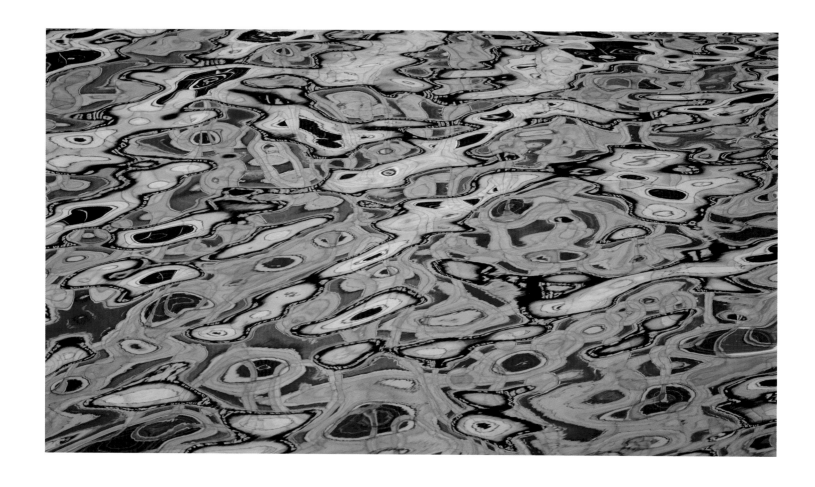

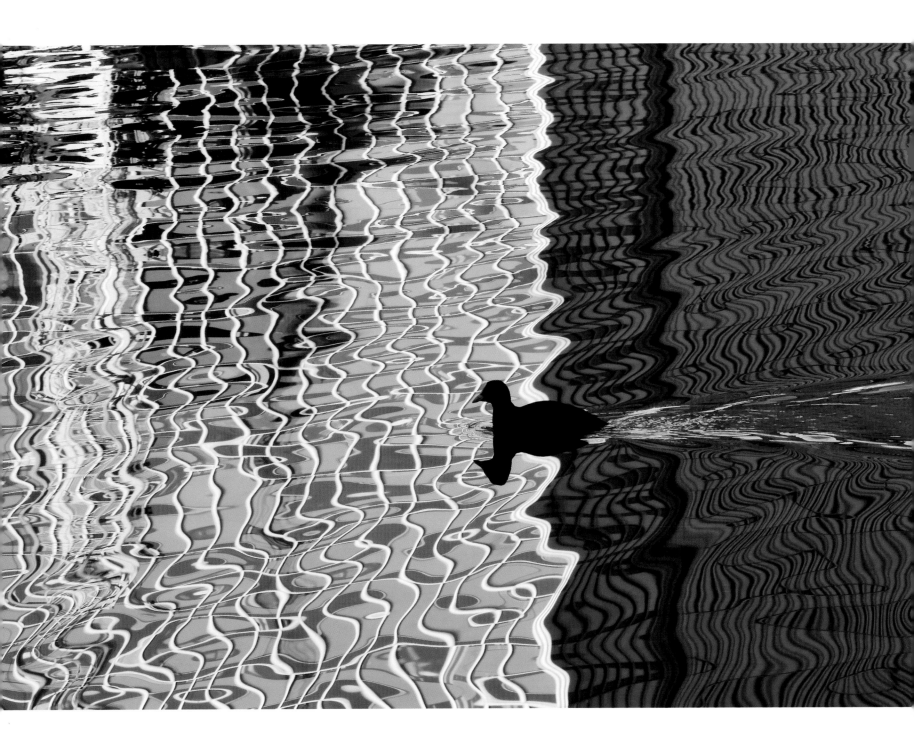

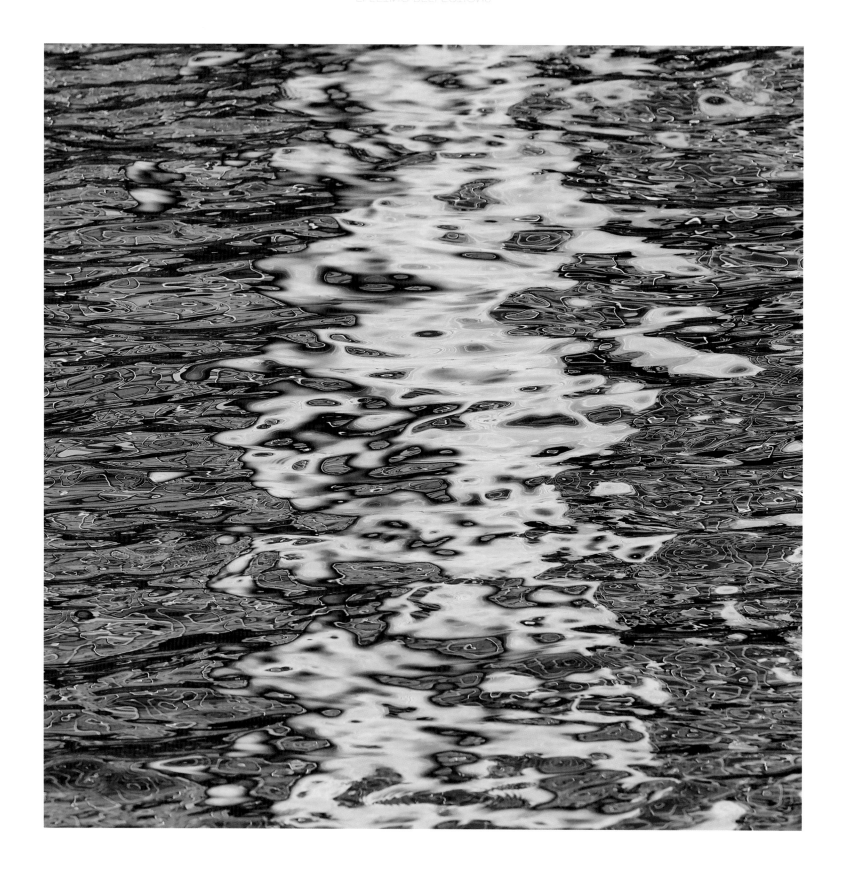

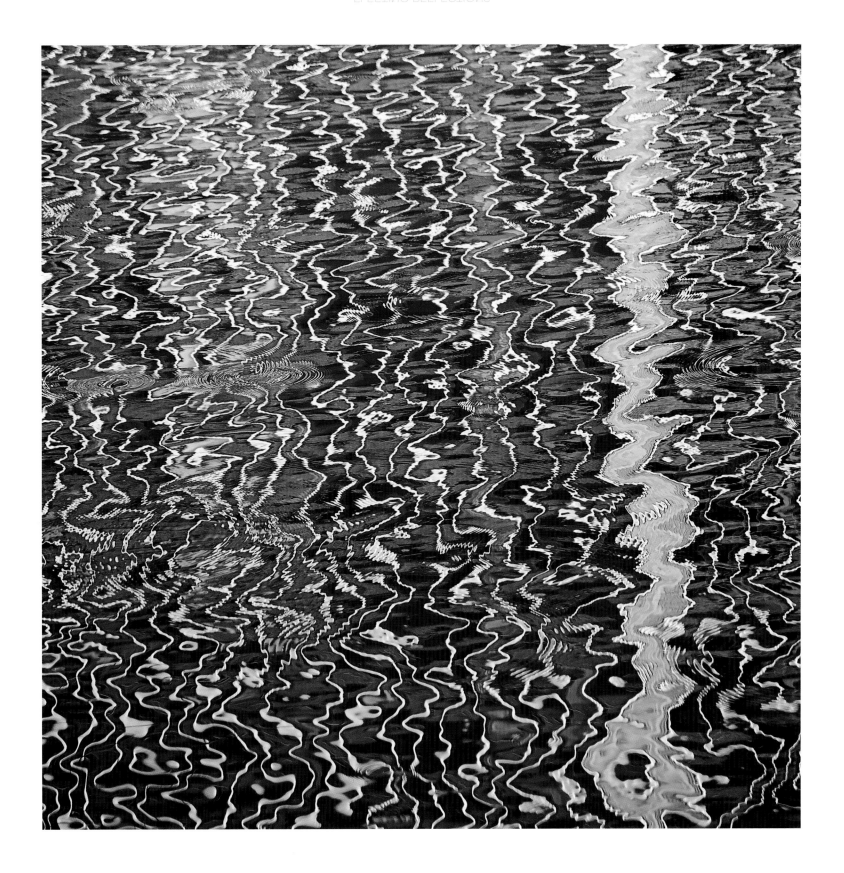

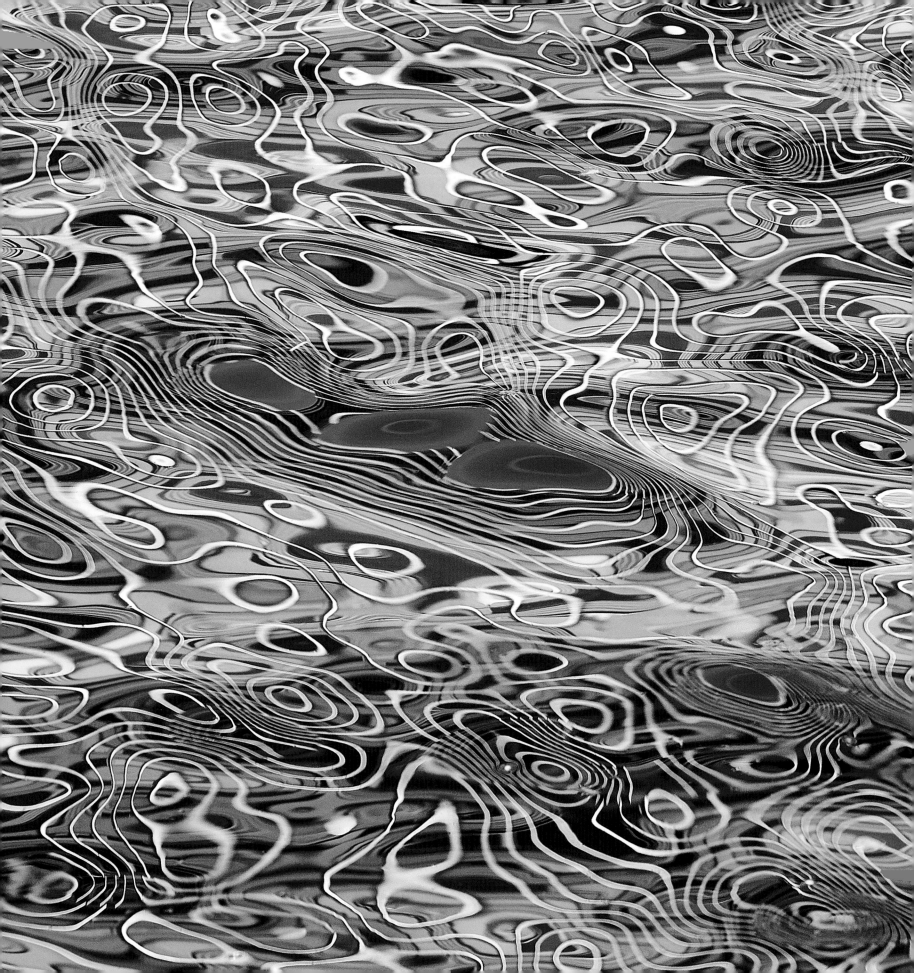

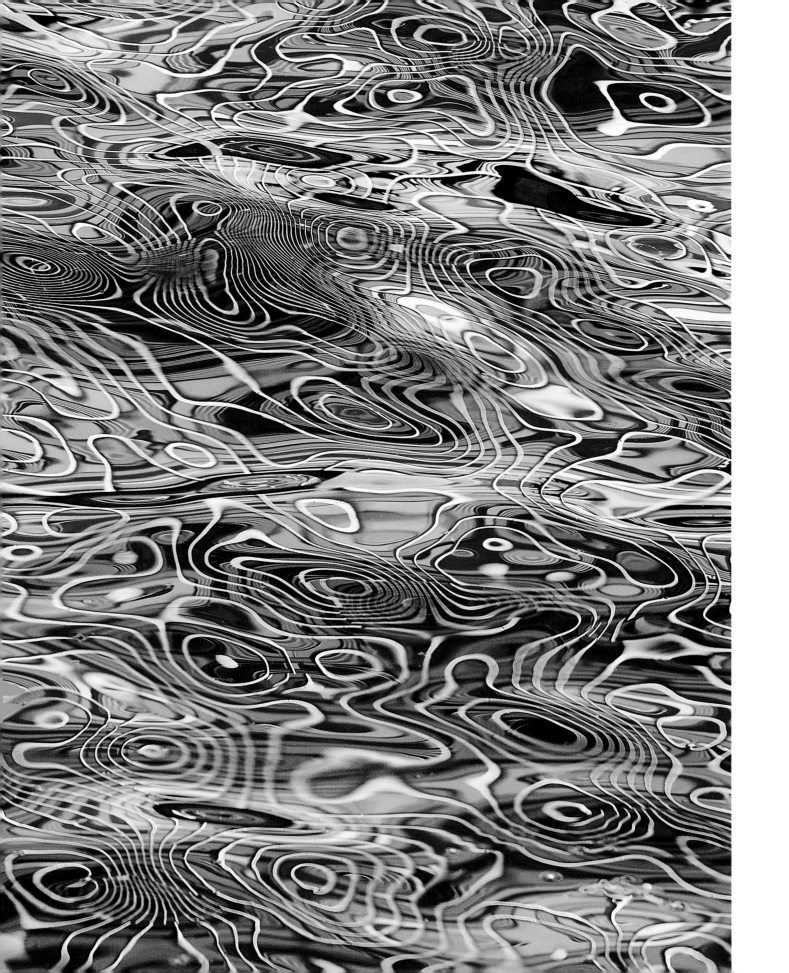

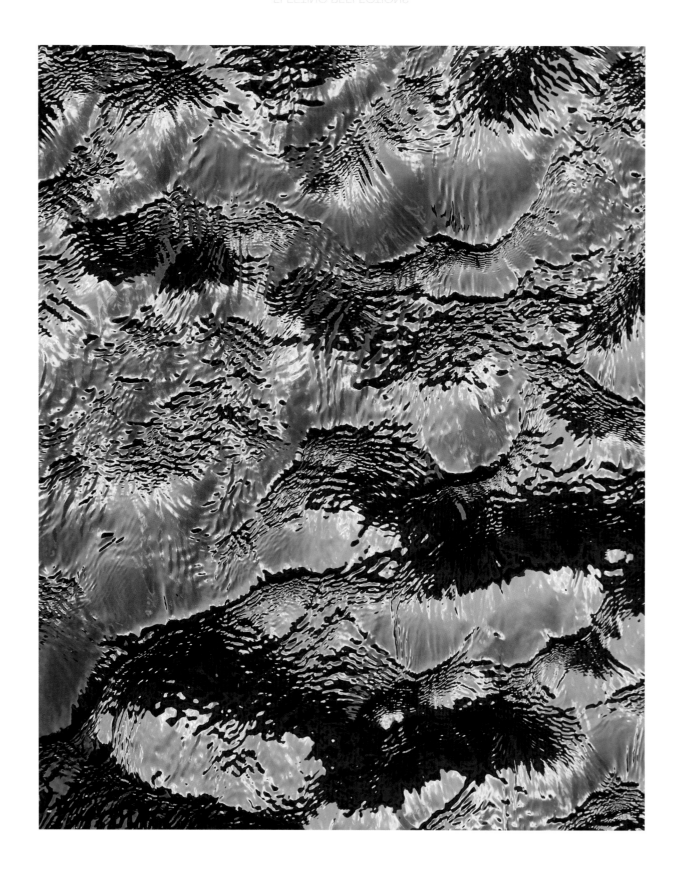

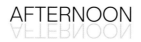

AFTERNOON

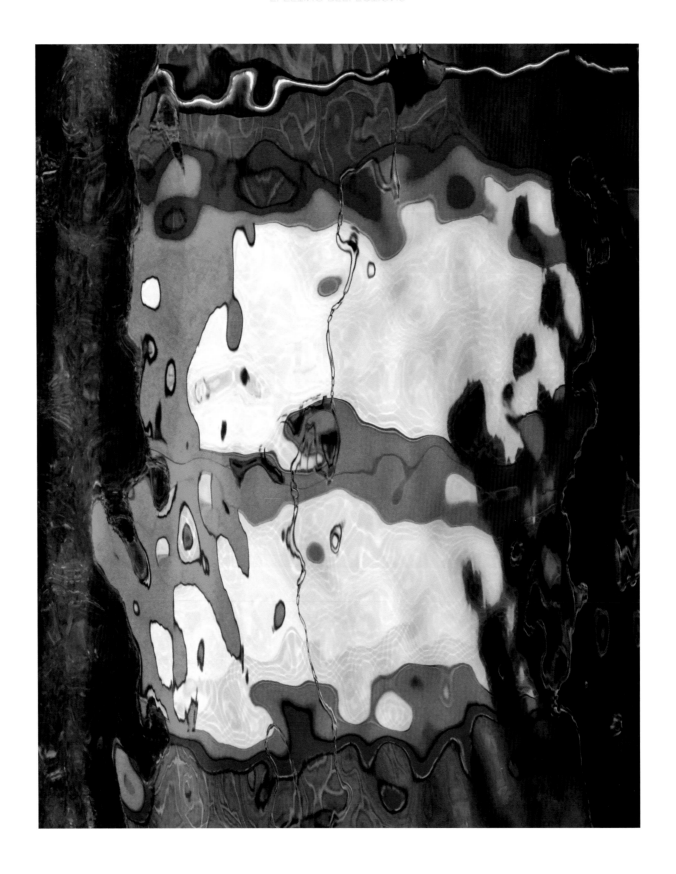

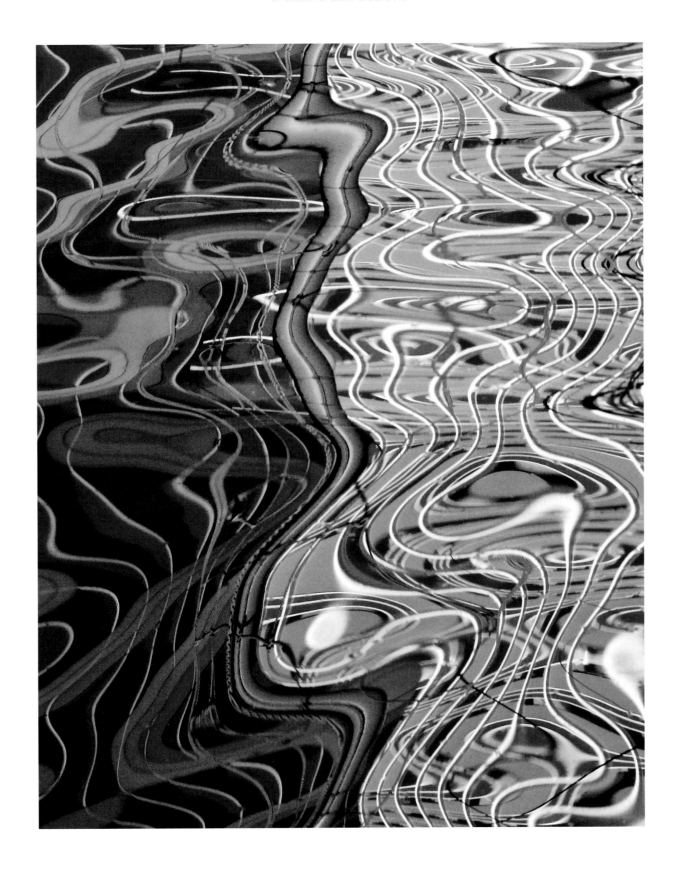

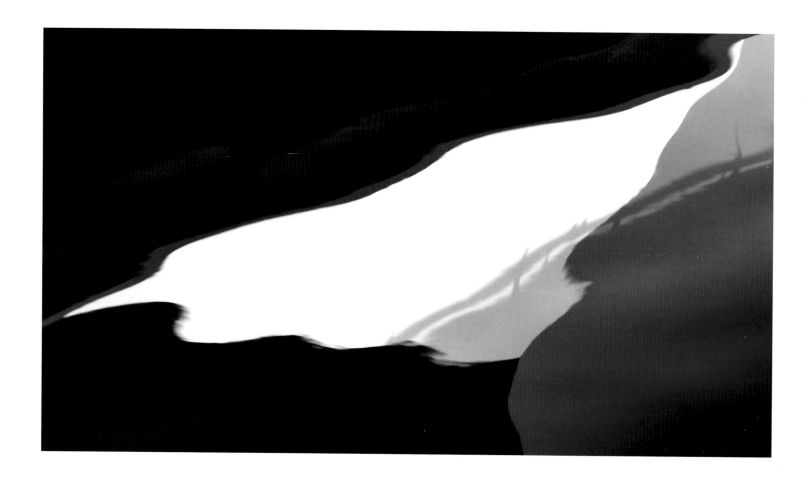

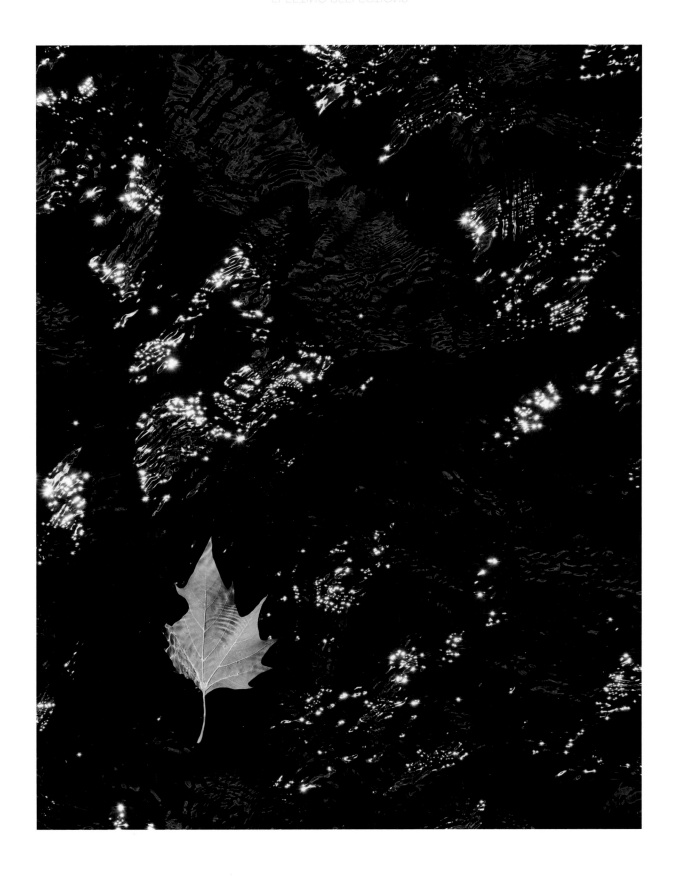

FLEETING REFLECTIONS

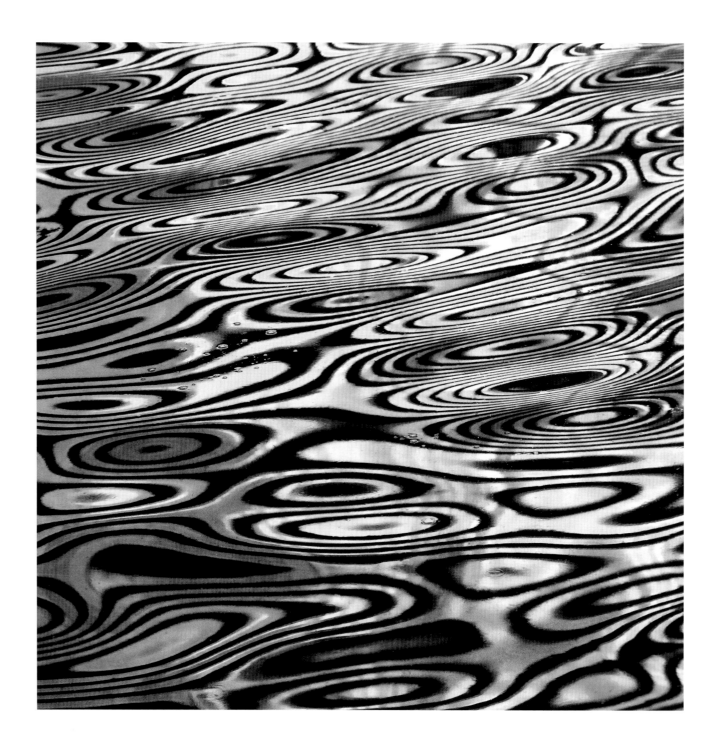

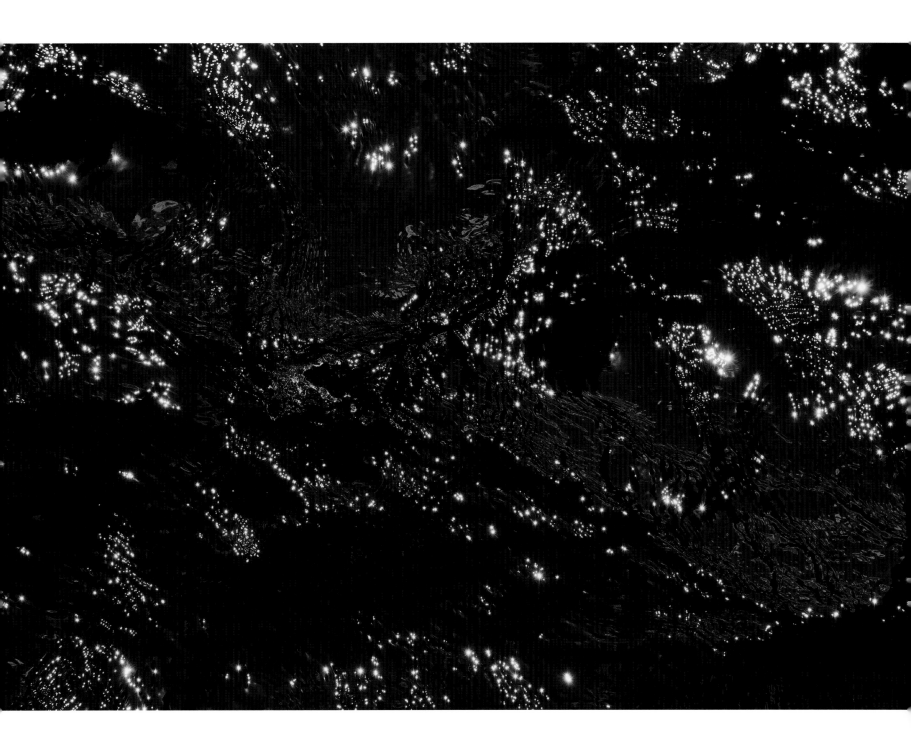

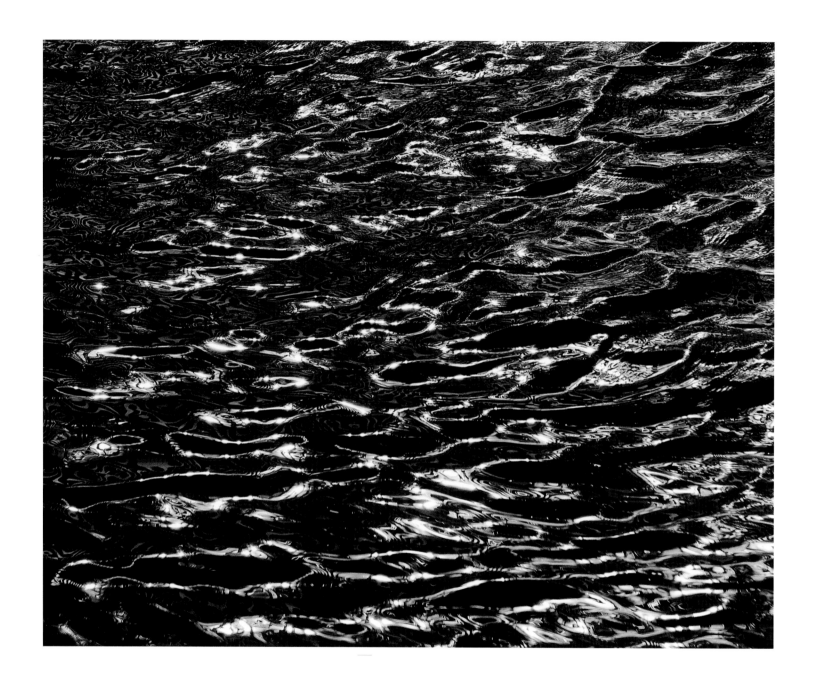

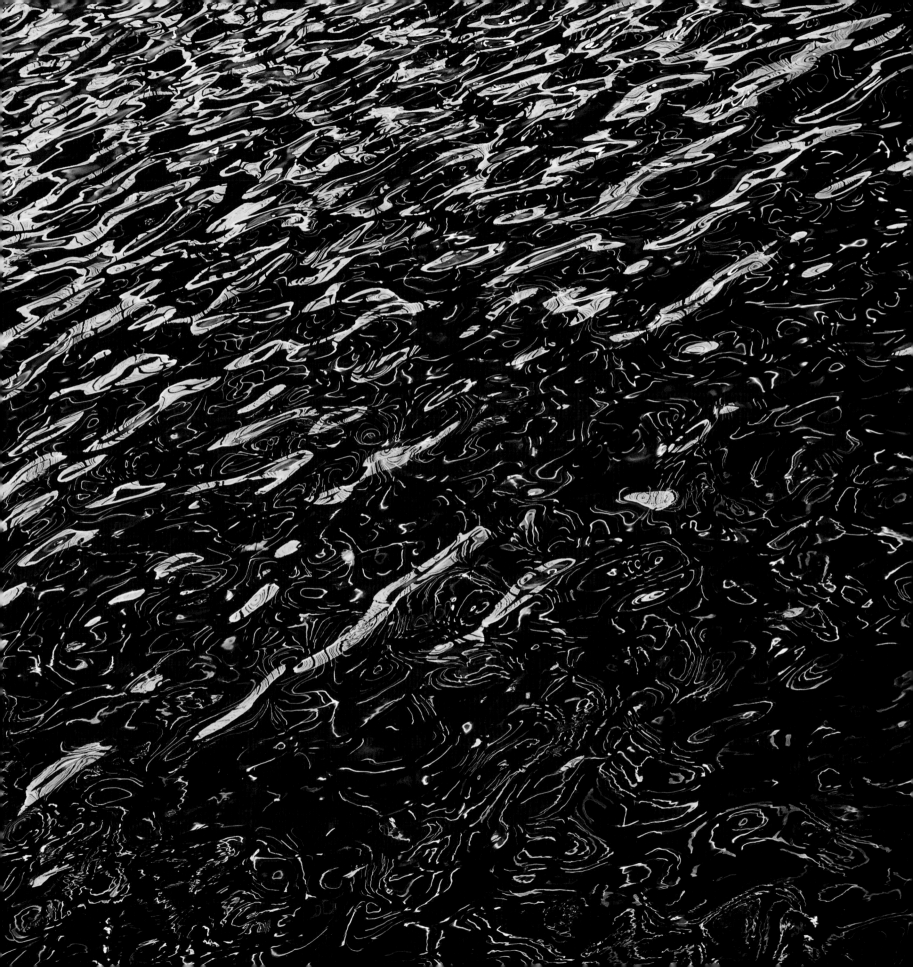

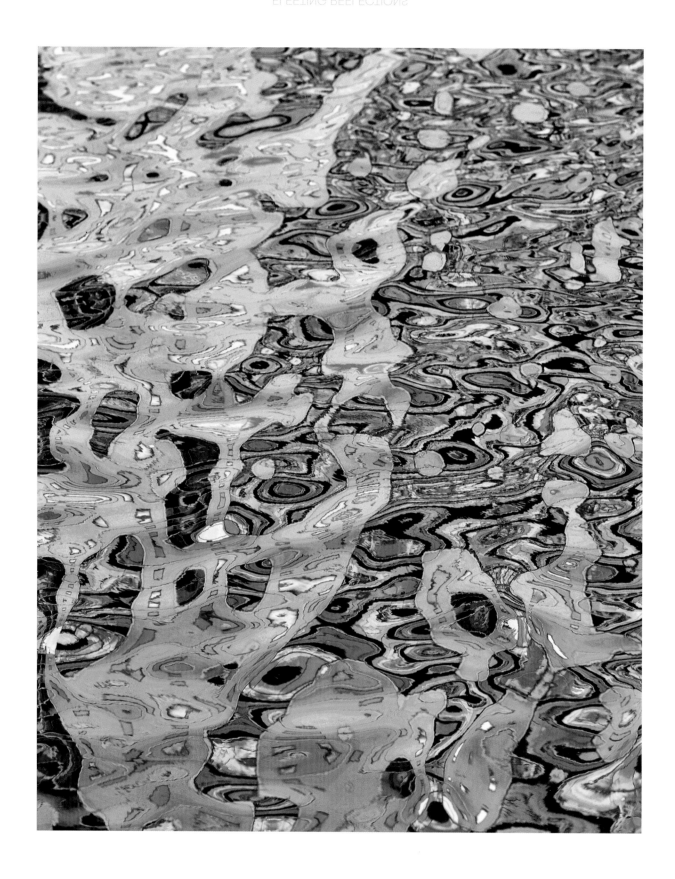

EVENING

FLEETING REFLECTIONS

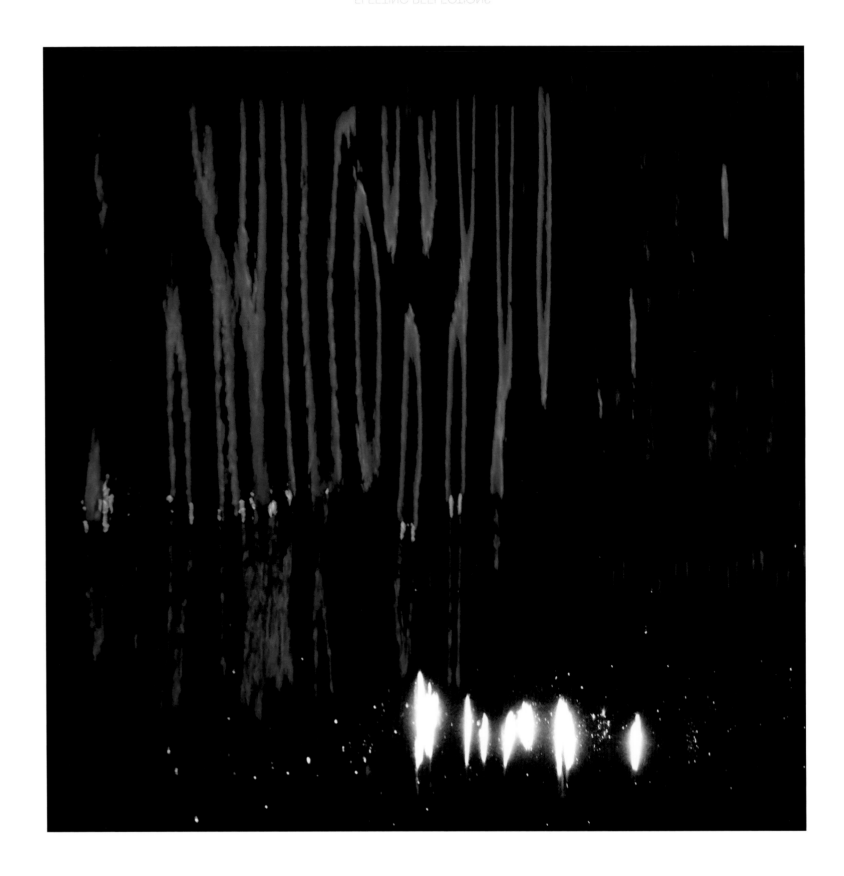

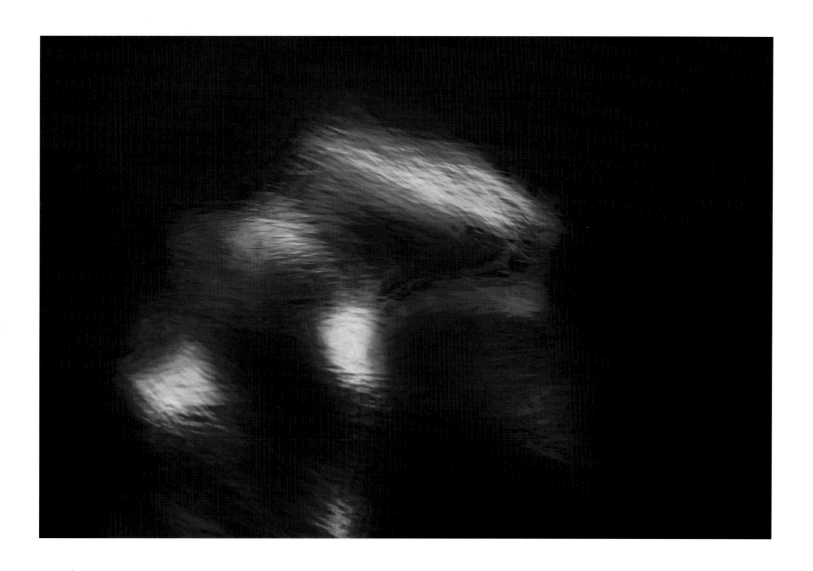

FLEETING REFLECTIONS

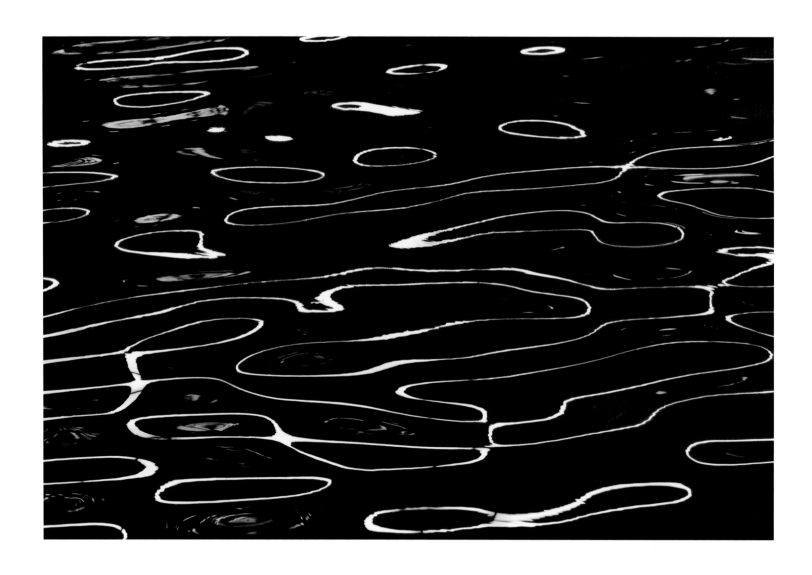

FLEETING REFLECTIONS

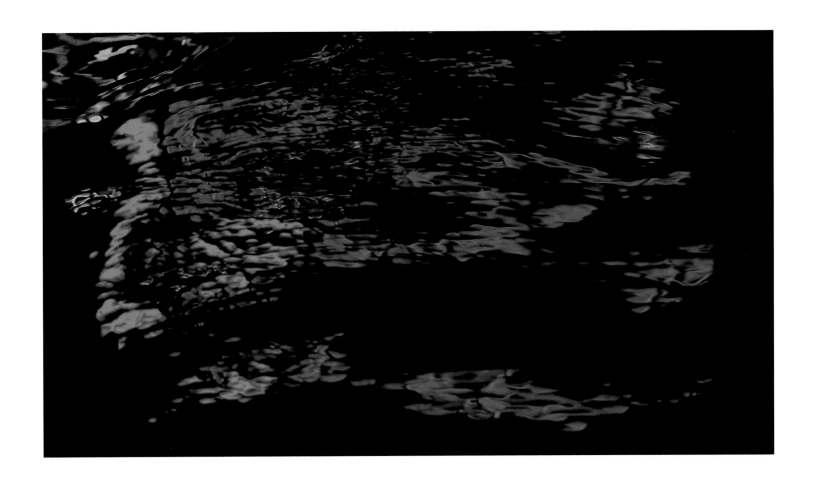

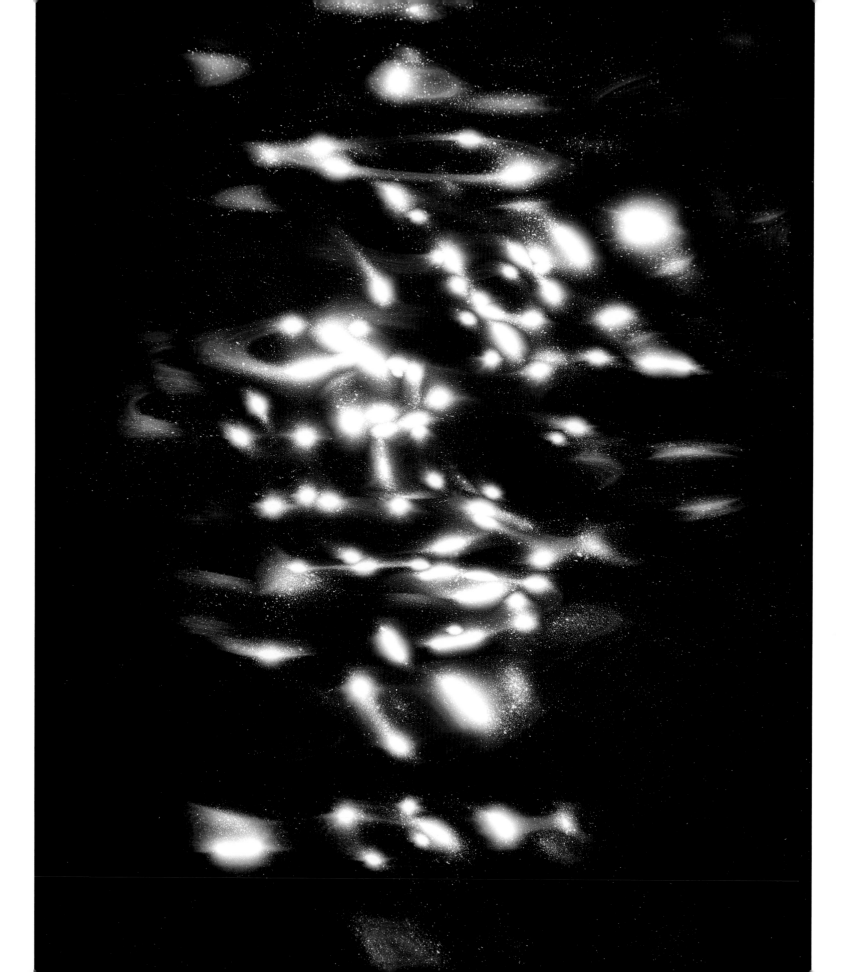

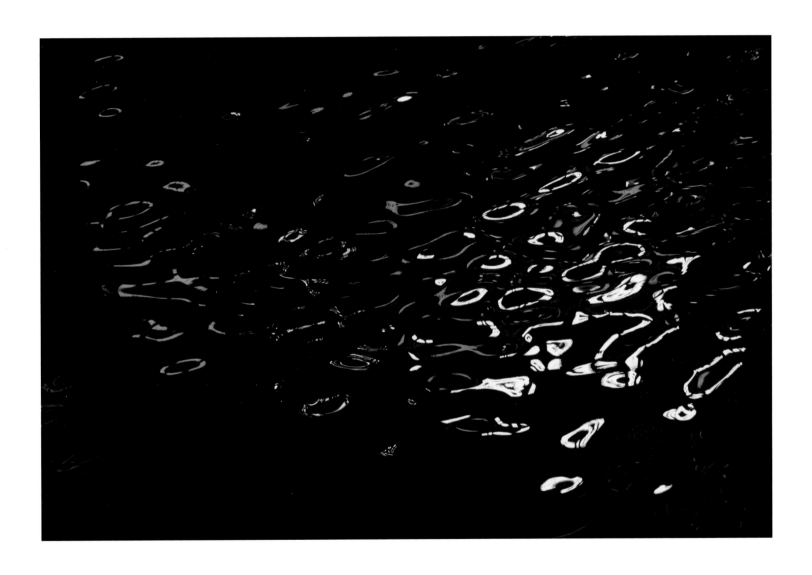

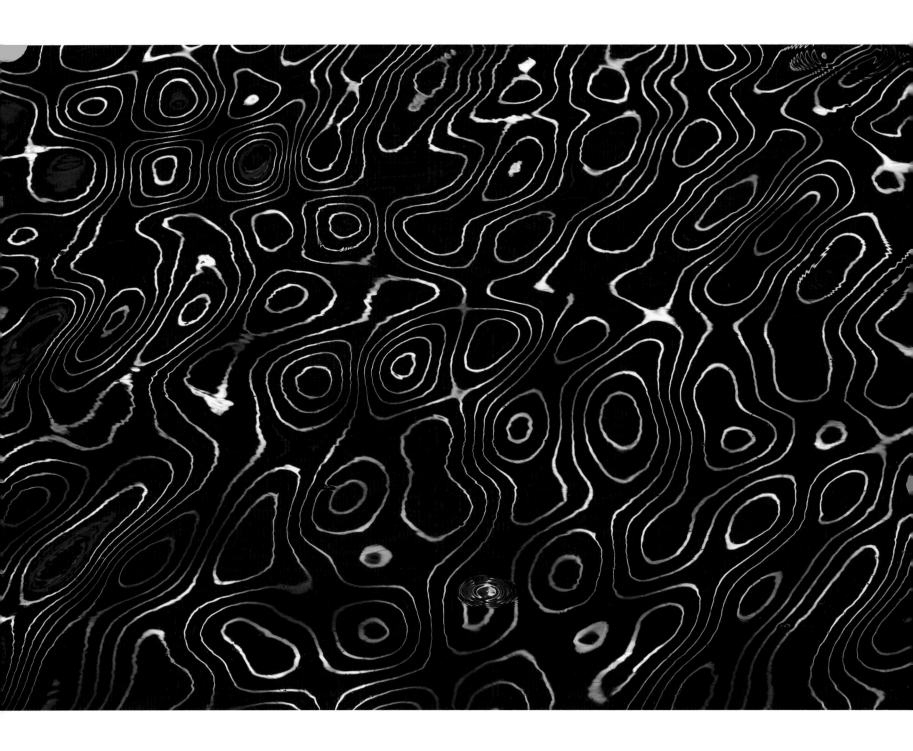

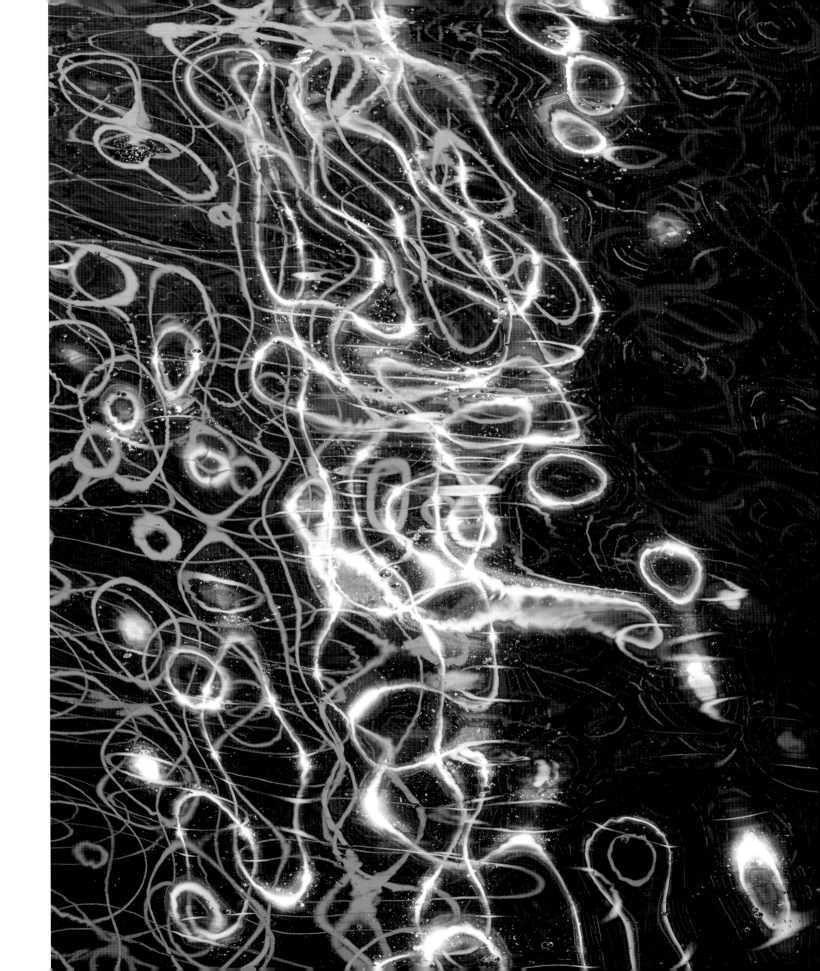

FLEETING REFLECTIONS

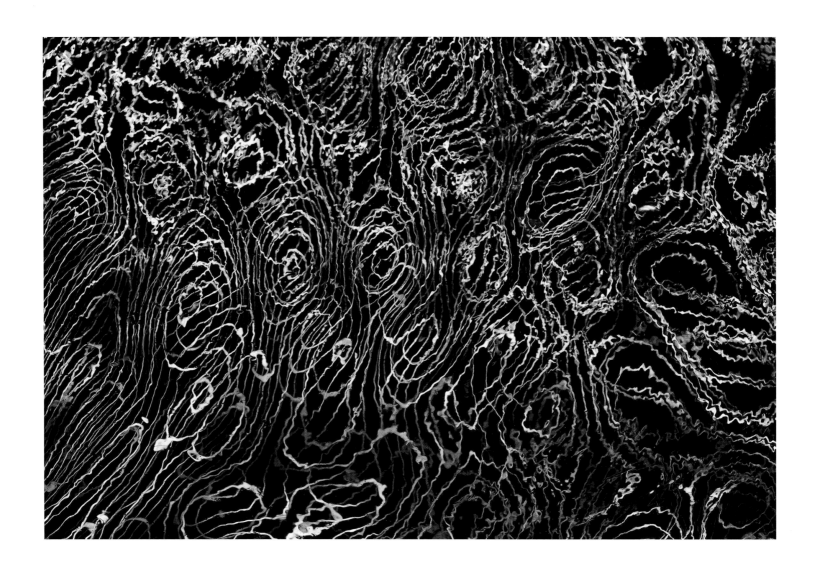

FLEETING REFLECTIONS

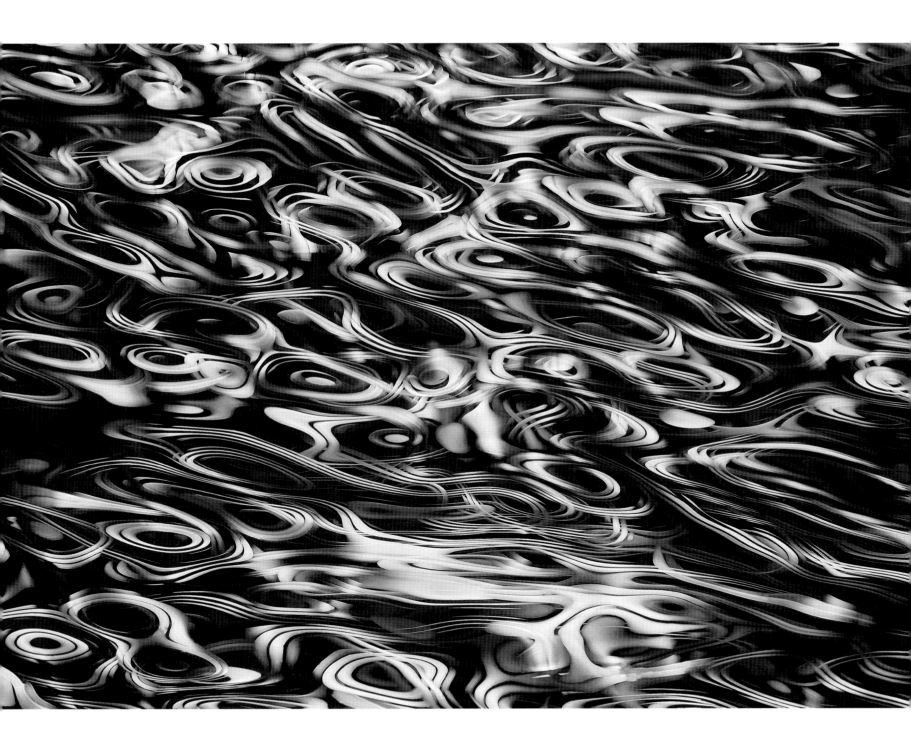

Mike Curry Photography is sponsored by

PRINT FOUNDRY

— IMAGERY REFINED —

www.mikecurryphotography.com

TriplekiteBooks

www.TriplekiteBooks.com

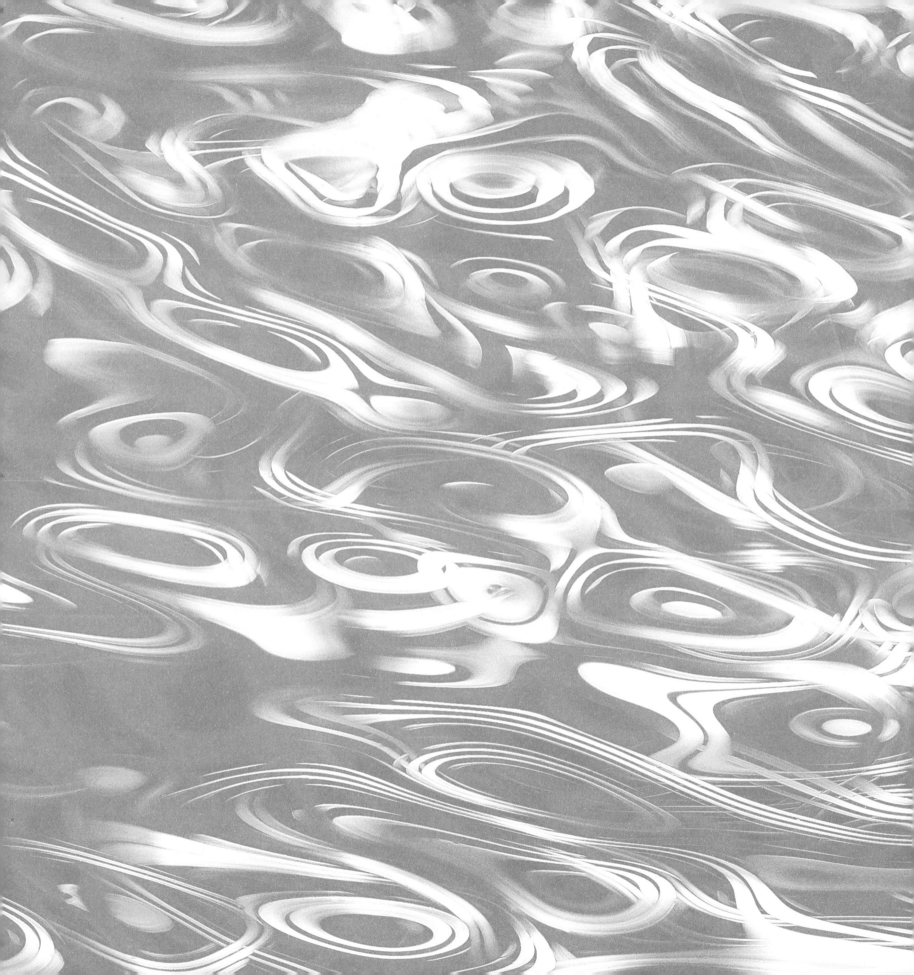